Having Fun with
PAINT

Sarah Medina

WAYLAND

First published in 2007 by Wayland

Copyright © Wayland 2007

Wayland
338 Euston Road
London NW1 3BH

Wayland
Hachette Children's Books
Level 17/207 Kent Street
Sydney, NSW 2000

Medina, Sarah
 Having fun with paint. – (Let's do art)
 1. Painting – Technique – Juvenile literature
 I. Title
 751.4

Written by Sarah Medina
Produced by Calcium
Design and model making by Emma DeBanks
Photography by Tudor Photography
Consultancy and concepts by Lisa Regan

ISBN 978-0-7502-4889-1

Printed in China

Wayland is a division of Hachette Children's Books.

Contents

Fun with Paint!

There are lots of different types of paint, such as poster paints and oil paints. People normally paint with a paintbrush, but you can also paint using a toothbrush, or by dipping paper into paint that has been mixed with water. These are some of the things you will need to make the projects in this book:

- Card
- Food colouring
- Oil paints
- Paper
- Poster paints

- Fresh fruit (grapes, banana and orange)

Note for adults
Children may need adult assistance with some of the project steps.
Turn to page 23 for Further Ideas.

Read the 'You will need' boxes carefully for a full list of what you need to make each project.

Before you start, ask an adult to:

• find a surface where you can make the projects.

• find an apron to cover your clothes, or some old clothes that can get messy.

• do things, such as cutting with scissors, that are a little tricky to do on your own.

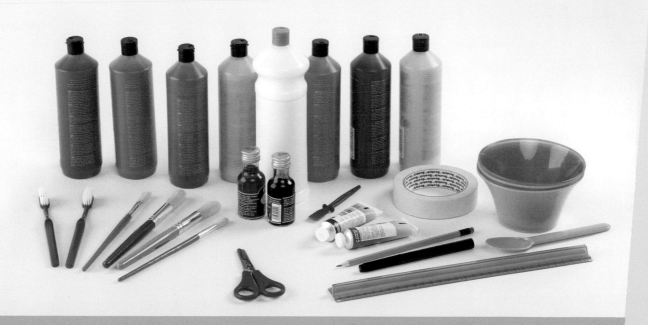

Funky Flowerpot

Make a funky flowerpot for a pretty plant!

1 Stick reinforcement rings and strips of masking tape in lines around your plant pot.

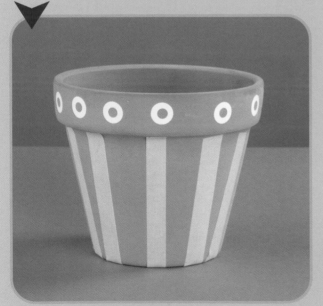

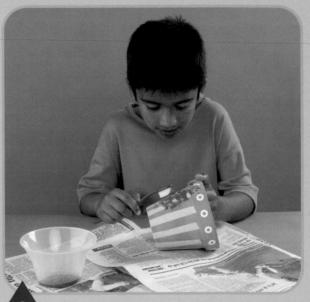

2 Dip your toothbrush into paint and dab over parts of the plant pot.

3 Repeat using different colours until the plant pot is covered with paint.

4 When the paint is dry, peel off the reinforcement rings and strips of masking tape.

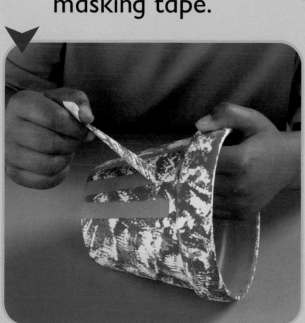

5 Put a pretty plant into your plant pot!

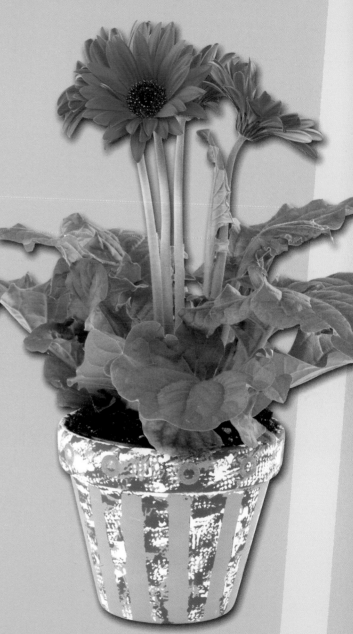

Magical Butterfly

Create a magical picture to put on your wall!

You will need
- 1 large sheet of paper
- Sequins
- Paintbrush
- Poster paints
- PVA glue

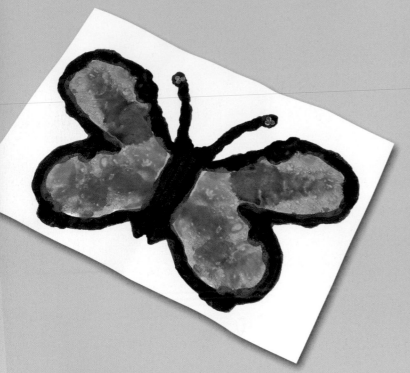

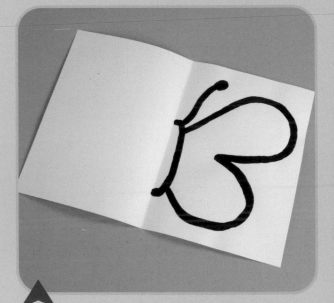

1 Fold a piece of paper in half and open it up again.

2 On one half of the paper, paint the outline of half a butterfly up to the fold in the paper.

8

4 Before the paint dries, fold the paper back in half and press down on it firmly. Open it up and leave it to dry.

3 Paint the butterfly's wing with a thick layer of paint. You can use more than one colour if you want to!

5 Glue sequins onto the butterfly's antennae.

Gift Wrap

Make a present extra-special with your own wrapping paper design.

1 Brush clean water all over the paper.

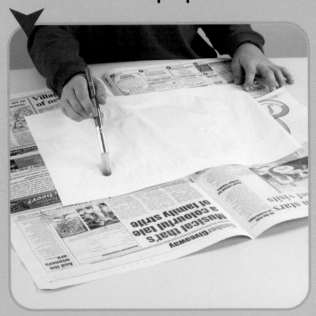

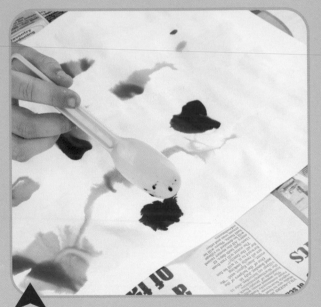

2 Whilst the paper is still wet, use a spoon to drop food colouring onto the paper.

4 Watch the colour spread all over the paper!

5 Leave it to dry. Use your wrapping paper to wrap a gift!

3 Whilst the food colouring is still wet, blow gently on the colours in different directions.

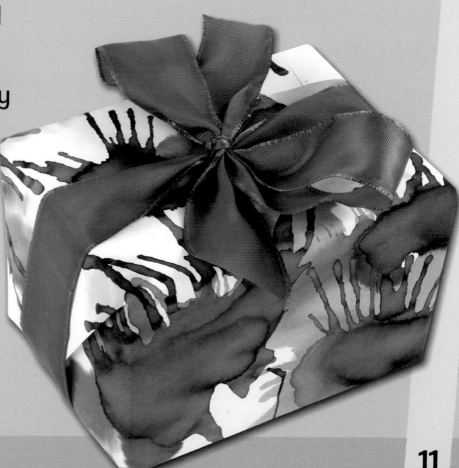

Still Life with Fruit

Surprise your family and friends with this modern art project!

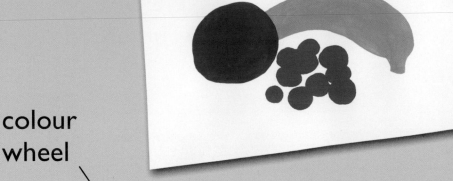

colour wheel

1 Lay your fruit on the table in front of you, and look at the colour wheel. Notice the colours on the wheel that are on the opposite side to the colours of the fruit.

3 Paint the banana in its opposite colour on the colour wheel

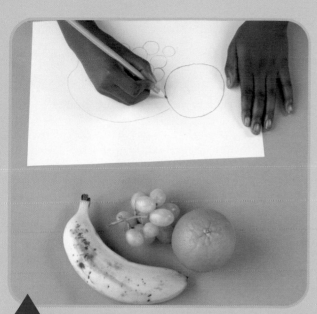

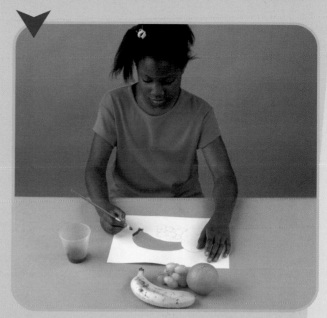

2 Draw a picture of the fruit on the paper.

4 Paint the orange in its opposite colour.

5 Paint the grapes in their opposite colour.

Marbled Gift Tags

People will love these marbled gift tags!

You will need

- Foil tray
- 2 tubes of oil paint –
 1 light colour and
 1 dark colour
- Ribbon
- Plastic spoon
- 1 sheet of thin card
- Hole punch
- Kitchen paper
- Scissors
- Water

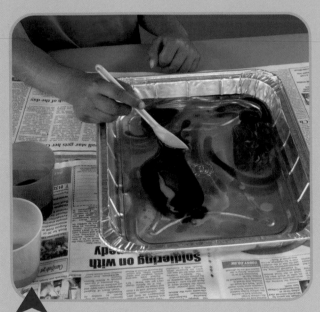

1 Put some water in the tray so it is two fingers deep, and gently swirl in a spoonful of each paint colour.

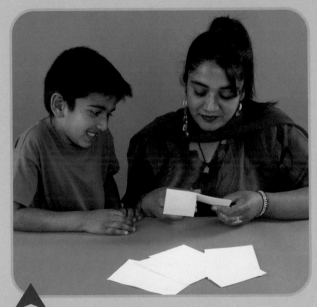

2 Cut the card into four pieces.

14

3 Place a piece of card onto the top of the water and gently move it around.

4 Remove the card carefully and leave to dry on kitchen paper. The painted side should face upwards. Repeat steps 3 and 4.

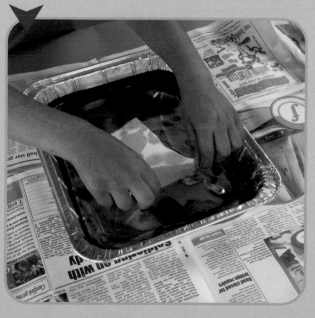

5 Fold each piece of card in half, make a hole on one side and tie a length of ribbon through the hole.

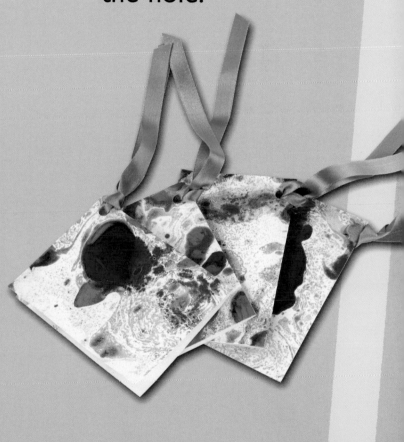

 Ask an adult for help with cutting card!

Flowerpot Man

Brighten up a plant with this flowerpot man!

You will need
- Large wooden spoon
- 1 sheet of white card
- Paintbrush
- Pencil
- Poster paints including yellow and green
- PVA glue
- Scissors

1 Place the spoon on the card. Draw large petals around the top of the spoon.

2 Cut the petals out and paint them in one colour or in different colours.

3 Paint the spoon handle green and then paint the spoon face yellow.

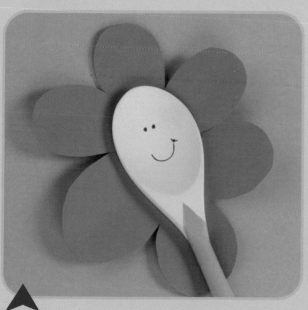

4 Paint a mouth, nose and two eyes onto the spoon face.

5 Glue the petals onto the back of the spoon face!

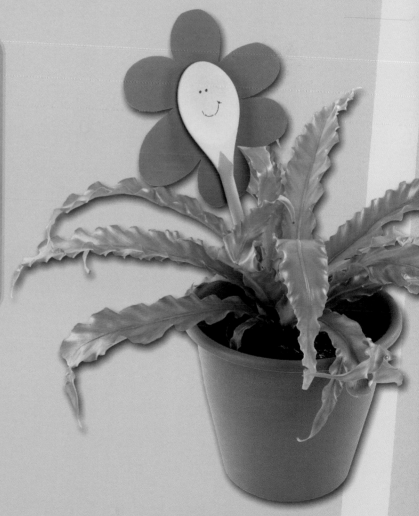

 Ask an adult for help with cutting card!

Door Hanging

Make a door hanging with a night sky for bedtime and a shining sun for morning!

You will need
- 1 white wax candle
- 1 sheet of thick white card
- 1 30cm length of ribbon
- Hole punch
- Paintbrush
- Poster paints – black and orange

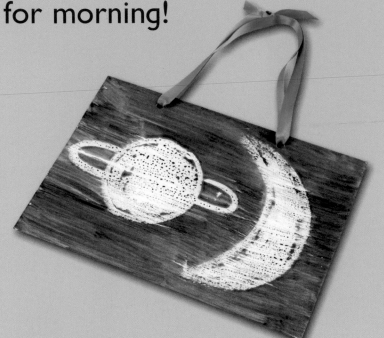

1 Using the wax candle, draw a moon and planets on one side of the card.

2 Paint the card black and watch the picture appear! Leave to dry.

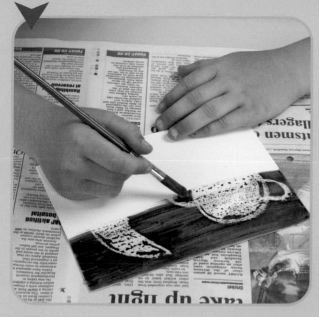

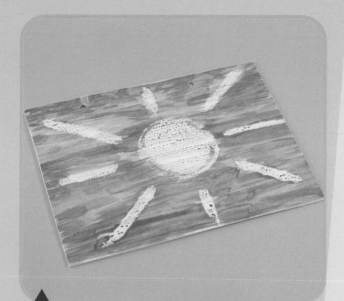

3 On the other side, use the candle to draw a large sun and its rays. Paint the card orange and leave to dry.

4 Punch two holes in the corners of the card and tie on a ribbon.

5 Hang on your bedroom door.

 Ask an adult for help with making holes!

Camouflaged Toy Box

Make a secret place to store
your toys!

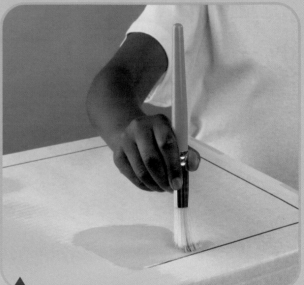

1 Paint the box and lid with light brown paint, and leave to dry.

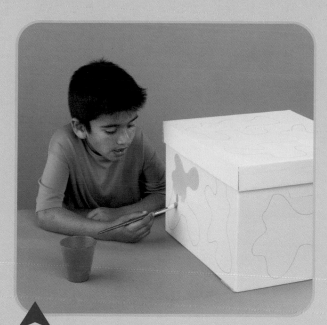

4 Cut the second piece of cardboard so it is the same height but slightly less wide than the short side of the box.

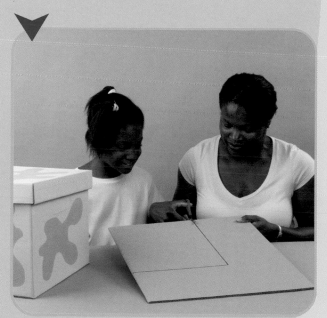

2 Paint camouflage patterns on the box and lid with green paint.

3 Cut one piece of cardboard so it is the same height but slightly less wide than the long side of the box.

5 Cut a straight line down the middle of each of the two pieces of cardboard. Do not cut right to the end!

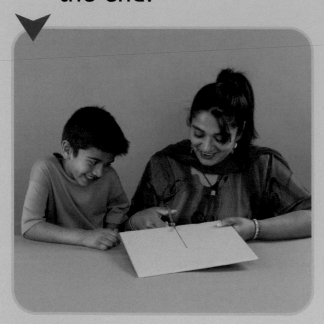

6 Slide the longer piece of cardboard into the centre of the box.

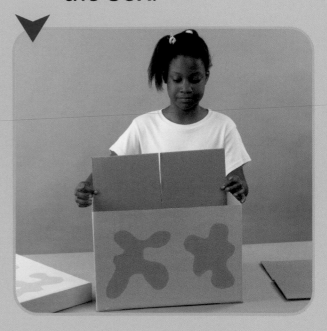

7 Slide the smaller piece of cardboard into the box to make four separate sections for your toys.

 Ask an adult for help with cutting cardboard!

Further Ideas

Once a child has finished the projects in *Having Fun with Paint*, they can add some other exciting finishing touches to them.

Funky Flowerpot
Paint a big, bright flower onto the front of the plant pot!

Magical Butterfly
Glue sequins all over the butterfly's wings to make them shine!

Gift Wrap
Use colourful pens to write your own messages, such as HAPPY BIRTHDAY, on the paper.

Still Life with Fruit
Add some other fruits, such as cherries, to the still life, using the opposite colours on the colour wheel.

Marbled Gift Tags
Dab PVA glue onto the gift tags, sprinkle glitter onto them and then shake off the excess glitter.

Flowerpot Man
Glue on wobbly eyes onto the flowerpot man, or glue on buttons for eyes instead!

Door Hanging
Stick shiny gold and silver stars onto the door hanging for added sparkle!

Camouflaged Toy Box
Use pieces of string to make handles for your box. Carefully press two holes in each side of the box, thread the string through and tie a knot inside to keep it in place.

Further Information

With access to the Internet, you can check out several helpful websites for further arts and crafts ideas for young children.

www.kinderart.com/littles/little19.shtml
www.dltk-kids.com/animals/mpeacock.htm
www.craftown.com/kids/kc47.htm
www.creativekidsathome.com/activities/activity_42.html
www.amazingmoms.com/htm/artpainting.htm
www.bbc.co.uk/cbeebies/artbox/artisttips/feature/colour_wheel.shtml

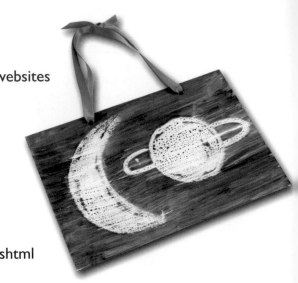

Glossary

camouflage a disguise using the same colours as the background, so the camouflaged item blends in

colour wheel all the main colours arranged in a circle, to show which colours look best together

marbling with a swirly pattern that looks like the naturally occurring pattern in marble (a kind of stone)

masking tape tape that is not very sticky, so it peels off easily

oil paint paint made with oil and colour, which is very sticky and takes a long time to dry

poster paint paint made with a kind of glue, which dries quickly and gives bright colours

still life a picture of an arrangement of objects (instead of a portrait or landscape)

Index